ART

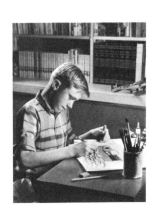

BOY SCOUTS OF AMERICA
IRVING, TEXAS

REQUIREMENTS

1. Tell a story with a picture or pictures.

2. Promote a product or an idea with a picture or pictures.

3. Record in an art medium something that you have done or seen.

4. Decoreate something with an original design. Put the design on Scout equipment, furniture, ceramics, or fabric.

5. Design something useful.

6. Render a subject of your choice in four of these ways:
 a. pen and ink
 b. watercolor
 c. pencil
 d. pastel
 e. oil
 f. tempera
 g. acrylic
 h. marker

7. Discuss job opportunities in art.

33320
ISBN 0-8395-3320-9
©1968 Boy Scouts of America
2000 Printing of the 1968 Edition

CONTENTS

WHAT IS ART?

The question of what art is has occupied the thoughts of philosophers ever since man began to think. We are not going to give a final answer in this booklet.

For our purposes, we will define art as whatever creates beauty or emotion in the mind of the beholder. By this definition, a movie, a stately building, a flower arrangement, a nicely printed letter, or a graceful lamp can be art objects just as much as a painting or drawing by a master. A useful thing like a table can be an object of art if its lines and construction are so good that it is beautiful as well as useful.

This merit badge pamphlet makes no attempt to cover all of the arts. Stress is laid upon drawing, painting, and design. When you have completed the requirements for the Art merit badge, you may want to work for some of the other merit badges that concern either the fine or useful arts: Architecture, Basketry, Drafting, Landscape Architecture, Model Design and Building, Music, Photography, Pottery, Printing, Sculpture, Theater, and Wood Carving.

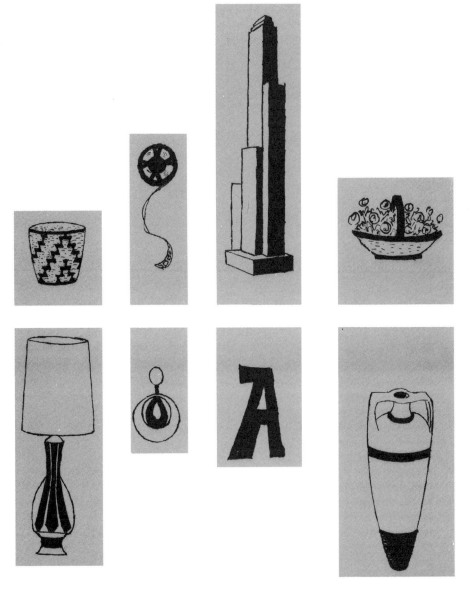

1

Prehistoric artists were story-tellers first; artists second. Their paintings and carvings on the walls of caves and cliffs are the only clues we have to how they saw the world. Even today, much of our art is aimed at telling a story. Cartoon strips like this one are not the only way stories can be told. Often single pictures tell vivid stories. For example, how about a picture showing a Scout holding bathing trunks on a beach with a "No Swimming" sign. That one scene would tell a clear story of frustration and disappointment.

STORYTELLING

The illustration on page 9 is a beautiful example of a story told in one picture. It is called "The Scoutmaster" and is by Norman Rockwell, one of America's greatest artists. In this picture, he has told a story of a Scout camp; the end of a busy day, the Scoutmaster thoughtful as he looks over the sleeping camp above the dying embers of a cooking fire.

Now you may be saying, "But I can't draw that well! All I've ever done is some stuff in school and some messing around at home."

No one expects you to produce a picture as technically perfect as this one. Rockwell has, after all, in addition to a great talent, long years of practice. Even if you *do* have a lot of natural ability in art, it would be many years before you could match the perfection of this painting.

But you *can* tell stories with pictures. In doing this, the most important thing is not how well you draw but how well you *see*. An artist, whether he is telling a story, painting a lovely landscape, or creating a geometrical pattern, is trying to communicate with the viewer. He wants to tell the viewer something about life. To do that, he must first have an *idea*—something to be communicated.

In art that tells a story, the *idea* is paramount. If you have nothing to communicate, you will have no story to tell. Look around you with your eyes *and your mind* wide open. Chances are there are plenty of "stories" just waiting to be told in pictures. Is there a Scout in your troop who is not very well liked by the others? Then show him sitting, forlorn and alone, in a corner, while the others in his patrol play Steal the Bacon. Does your dad groan and mumble and tear his hair when he's paying the monthly bills? Then try sketching him at work with his checkbook while your mother peeks around the corner to see how bad the storm will be this time. These are, of course, very simple stories, but nearly all great art is simple in that it communicates only one idea. Keep your eyes and mind ready to receive the impressions that will give you the great idea for your picture story.

If you choose to do a cartoon strip for this requirement, be sure the pictures tell the story. Don't just illustrate a joke. It is *not* a picture story when the whole story is told in the "balloons" over the characters' heads; words may be necessary in a cartoon strip,

but they should just help explain the action or emotion the drawings show.

You can use any medium you want: pencil, pen and ink, paint, even a tapestry design.

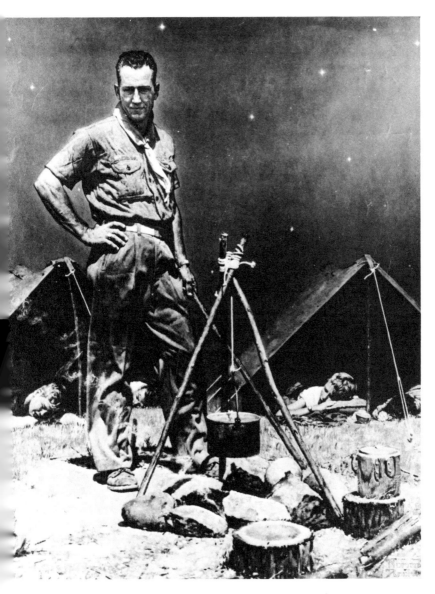

2

2. Promote a product or an idea with a picture or pictures.

Almost everything you see or touch every day has the work of an artist in it. Everyone likes things to be beautiful as well as useful, and even so lowly an item as your personal toothbrush has been designed to appeal both to your eye as well as your mouth.

When you hear the word "artist," probably you think of a paint-spattered man with wild hair working at an easel in some lonely room. But

SELLING WITH ART

for every one of him, there are a hundred other artists and designers working with many other men on newspaper and magazine ads, in factory design offices, in publishing companies, and in art studios. They are intent on drawing or painting an article or an

idea that will influence the viewer to buy the article or consider the idea; or they may be making a design for a manufactured item to make it more attractive to the public.

This field is called, very broadly, commercial art. Although you may not have thought of it that way, probably you have already done some commercial art in school. Making a poster in art class or a display card for a Scout exhibit is an example.

In this field, the *message* is the important thing. The artist tries to create a desire for his product or "sell" an idea. With pictures—and usually words—he tries to make the product or idea as appealing as he can.

Similarly, the designer, whether he is working on a package, a toothbrush, or a car, hopes to create a feeling of beauty that will catch and hold the eye of even the casual viewer.

If you choose to meet this requirement by doing an ad layout, study some magazine and newspaper ads before you start. Laying out an ad means putting together the elements of art and text in an eye-catching way. Don't simply copy or rearrange an ad for soap or automobiles that you find in studying ads. Select something *you* know about —your school play, your Scout show, your community clothing drive for the poor. Dream up a catchy punch line for the ad: For a mystery play it might read Can *You* Stand the Suspense? and for a Scout show try Great Scout! It's a Blast!

Begin making your layout by drawing small sketches of your idea for the ad until you have one that best promotes the idea. Go on from there to your finished ad layout in any medium.

If you want to do this requirement with an industrial design or a sample of architecture or interior decoration, you will find advice on the basics of these arts in the book list at the end of this pamphlet.

3

ART FOR THE FUN OF IT

This requirement is as wide as all outdoors and just as much fun. You can use any type of art medium from pencil to oil and pick just about any subject that interests you.

Naturally you will want to make your picture as good as you can. Start with a few very simple sketches of your idea on scrap paper. Then you can begin to draw the real picture.

Probably you have learned a little about drawing and painting techniques in school. If you want to brush up on such things as composition, perspective, and how to show action, turn to pages 36 and 37. There you will find tips on techniques.

The essence of the art of painting is seeing something and then transferring your vision to paper or canvas.

Suppose you have decided to make your picture "from life." How do you go about it? Well, first of all, you don't make the completed sketch or painting out in the wilderness. Instead you go into the field with an artist's sketchbook or a handful of any kind of paper and make sketches—lots of them. Then, when you return home, you have the raw material for your finished picture. Armed with your sketches and the memories of flashes of color, the splash of sunlight on the trees, and the feathery clouds overhead, you draw or paint your finished picture.

Suppose you have decided to make your picture "from life." How do you go about it? Well, first of all, you don't make the completed sketch or painting out in the wilderness. Instead you go into the field with an artist's sketchbook or a handful of any kind of paper and make sketches—lots of them. Then, when you return home, you have the raw material for your finished picture. Armed with your sketches and the memories of flashes of color, the splash of sunlight on the trees, and the feathery clouds overhead, you draw or paint your finished picture.

If you want to do a landscape in the country with perhaps some life in it, go to an open woodland. Settle quietly in some place where you will have a broad view. Before you is a small shallow brook. The water flows softly around a big boulder. Bubbles and bits of sticks or leaves float lazily downstream. Scatter some grain or sunflower seeds or crumbs among the rocks or along the shore.

You wait quietly, sketching as you watch. There is a movement and flash of light among the trees. It comes nearer. It is a bird, larger than a sparrow but not so big as a crow. It lands on the rough trunk of a tree. Something startles it and away it flies. A large white spot shows on its back near the tail. It is a yellow-hammer or flicker.

You try to make a sketch of your impression or memory of it—how it landed, how it beat its wings to take off again. Sketch everything you remember in your sketchbook. If you have some colored crayons with you, add a few bits of remembered color. Lay the sketches beside you and wait with a fresh paper in front of you. The bird may return.

While you wait, study the way sunlight falls across the surface of a tree or on the water-worn boulder. You may go home with a dozen sketches, none of them complete but each of them holding some key to the scene as you saw it. When you begin working on your picture, you will take bits and pieces of these sketches and put them in. The result will not be a photographic copy of the landscape; rather it will be your own vision of that scene. In other words, it will be art.

In drawing animals, birds, and other things that won't stay put, some artists find it useful to have a

large sheet of paper fastened on a board. As the animal moves into different positions, they start new sketches on the same sheet. Often the animal will come back to a position it was in before, and the artist then goes back to that sketch to make a few more strokes with his pencil. Gradually, he finds himself with a few nearly completed drawings and a number of partly finished ones.

Perhaps his final picture will show the animal in a position that he has not even sketched. But he will be able to make a better picture, because with his sketches he knows how the animal looks in many different positions. In short, he knows more about the animal than he would if he made only one sketch and then tried to make the completed picture from that.

In a city there are many exciting places you might go to make sketches: a harbor, a bridge over a river, a market, a parking lot, an aquarium or zoo, an athletic event, to name just a few. Or you can look about your own neighborhood, at a playground, a grocery store, a bicycle shop, a pet store, a shopping mall.

Another idea is to get a small sketchbook, or make one of scrap papers, and carry it with you when you are going about to various events and places. When you get a chance jot down quick impressions with your pen or pencil. You can find many interesting ideas to draw while riding a city bus or waiting for a bus. Draw people's shapes and faces as they stand or sit or talk or read, and note how each one is different. Do they slump or sit up straight, is one very tall and another short and stocky, is someone reading a newspaper and another looking out the bus window, are two people talking to each other, is someone dozing? Try to sketch them quickly. Other interesting places for sketching would be a ball game, an amusement park, a picnic, and a restaurant.

If you decide to draw or paint something seen under a microscope or through a telescope, your problem is a little different. Artists who work in science try to render their subject *exactly* as it appears, including the precise color of the object. For a geometric pattern like the snowflake seen here, a ruler and T square would be used for lines and angles. Paint the finished drawing so that it is as exact a copy of what you saw through the lens as you can make it.

4

APPLIED DESIGN

Designs for decoration should be simple, balanced, and appropriate. An elaborate painting of a city street would look awful on a chair in your troop meeting room. On the other hand, the stylized fish on the patrol flag shown looks just right—at least if the patrol has a fishy name!

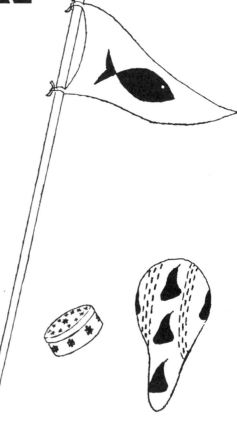

Nobody ever saw a fish that looked quite like the one on this page. Why, then, is it a good design? Because it is simple, beautifully balanced, and easy to understand. Other good designs, including the one at right, do not represent any real object like a fish; they are merely pleasing groupings of lines, arcs, and angles. Your design may be from nature or from your imagination.

Just as the fish design is a simplified, streamlined shape based on a fish's natural form, so you can look for nature objects and make your own designs from them. For example, look about you and collect various nature objects: a pebble, a piece of tree bark, sticks, an interesting leaf, a nut hull, and similar objects. Then study each carefully, and closely observe the shapes and textures, the curves or straight lines, the hollows. Then experiment with a pencil, making simplified shapes based on these objects. Keep making several sketches of each until you find a design you like for each.

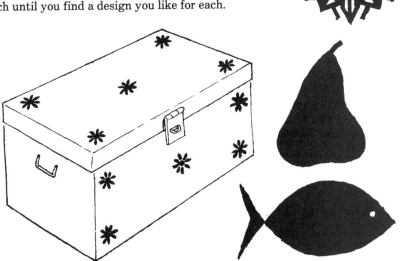

Most things in nature are balanced. A leaf, a flower, or a paw print seem somehow complete. Nothing more is needed, and nothing could be taken away without making the leaf, flower, or paw print seem unfinished.

Whether you use an object from nature or an idea in your mind as the starting point for your design, try to put it in balance. Keep it simple. You do not need to show every vein of the leaf or every pistil of the flower for good design. Simplicity is the goal of every artist, especially of the designer.

On these pages you see a number of good designs, any one of which could be put on your Scout equipment or on furniture in your troop meeting room. But the requirement calls for you to make an *original* design. This means that you must exercise your own imagination and create something new.

Start with a piece of paper and a pencil. If you don't have much of anything in mind, doodle a while. Often doodling will suggest an idea for a good design.

Or you may begin by playing around with variations of some present design. Take the universal Scout emblem, for example. Doodling with that emblem in mind might give you an idea for an original design which has a hint of Scouting and yet is entirely new.

The shape of an elm tree, the head of a bear, or the outline of your Scout knife might suggest some good design. Play with it a while, adding a line here and subtracting one there, until it seems just right.

Your doodling may lead you to a geometric or an impressionistic pattern like the ones on this page. Fine. If it seems pleasing to your eye, then it should be a good design. Generally, this type of design will be more appropriate to ceramics, knickknacks, and fabrics than to Scout equipment. For Scout things, a design that suggests nature and the outdoors will seem "right."

You must apply your design to some article after you have made it. How you go about this depends mainly on what the article is.

If it is a piece of furniture like the troop chest on page 19, you could simply trace the design where you want it and then paint. If you want to put your design on the patrol flag by the easiest method, you could trace it on a piece of cloth of the proper color, cut it out, and sew it on the flag.

Putting designs on leatherwork, such as your ax or knife sheath, or painting on ceramics calls for other

skills. For advice on them, see the *Leatherwork* or *Pottery* merit badge pamphlets, or one of the books listed at the end of this booklet. The skills for working leather and painting on ceramic objects are not difficult but they do require knowledge outside the scope of this booklet.

The most important thing for this requirement is not your ability to transfer your design to an article of equipment or furniture but the *design itself*. Does it show original thinking? Is it simple and balanced? Does it look "right" on the piece you have chosen for it? If the answers to these questions are "yes," then you have shown some ability for decorative design.

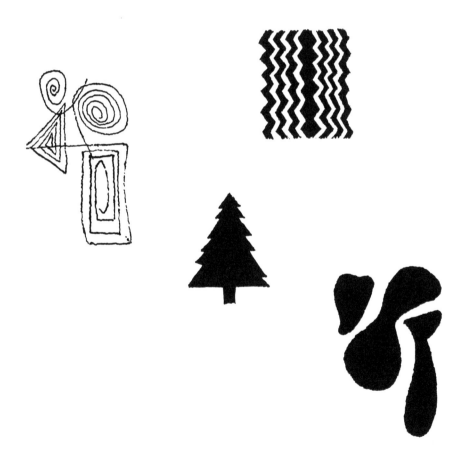

FUNCTIONAL

5

For Requirement 4, you were asked to make a two-dimensional design, one for decoration only. For this one, you must design in three dimensions—your article will have depth as well as height and breadth.

Whatever you choose to design, remember that it must be useful. It must be practical as well as beautiful. Possibly you could draw a chair with clean flowing lines and a colorful appearance that looked inviting. But if its seat were 3 feet off the floor, it wouldn't be much good, would it? Or you might sketch a beautiful car—sleek, powerful looking, and low—so low in fact that no one could get into it.

Start your thinking about a design by remembering what the article will be used for. Suppose you decided to design a new Scout ax. You want it to look good, but even more important, you want it to be able to do the work it's supposed to do. So you would decide questions like these: How big should the head be? How much cutting surface? Should the rear of the head be as wide as the edge? narrower? wider? How long should the handle be? The handle on the present Scout ax curves—it this good? How thick should the grip be?

When you have answered these questions, you are ready to start sketching. Perhaps you will end up with an ax designed quite like the present one, or you may decide that some other design would be better. Be ready to tell your counselor why you made the changes you did. Your completed sketch need not show dimensions as a working drawing does, but it should be drawn well enough that your design is clear.

If you want advice on design methods before you start, you can get it from some of the books in the back of this booklet. Also, for specific design projects, consult the following merit badge pamphlets: *Landscape Architecture, Architecture, Pottery, Model Design and Building, Sculpture, Wood Carving.*

DESIGN

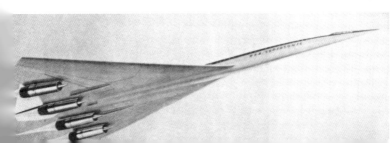

6

YOUR RAW MATERIALS

The artist has a wide variety of materials to use in making a drawing or painting. Probably, you have used most of the six kinds mentioned in this requirement either in school or at home. It would be a good idea now to try media you have *not* used before to get acquainted with them.

Each medium has qualities that make it good or poor for certain jobs. Try to learn what these qualities are so that you can choose the right one for your drawings and paintings.

There is not enough room in this booklet to go into a lot of detail about each media. If you want to learn more, you can do it from some of the books in the list at the end; but don't depend upon your reading to make an artist out of you. Practice and experiment and then practice some more; that's the secret behind learning how to make good drawings and paintings.

Pen and Ink

An artist who has a lot of experience with pen and ink drawing may put his pen to paper with nothing to guide him but his idea. With straight lines and swirls, spirals and loops, he may draw quickly a beautiful picture, delicately shaded and outlined.

But if you have never worked much with pen and ink, you may want to sketch the outlines of your figure with a lightly held, hard pencil before you begin with pen and ink.

Professional artists use special pens that give fine or heavy lines and soft or rich black tones as well as other colors. Probably, you will not have one. If you don't, a fine round-nib lettering pen is recommended. If you don't have one of those either, use any pen you can find.

Use a smooth-surface, heavy bond paper. Keep only about a half inch of ink in your ink bottle; this will

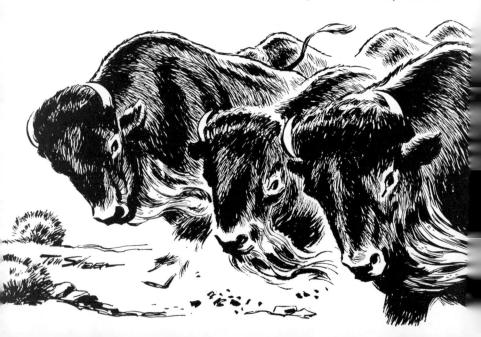

help you avoid spilling or blotting ink on your drawing, because you won't be able to get much ink on your pen.

If your subject is a living thing—a person or an animal—you can suggest its contours with light, spiraling lines that go "around" the figure. In the same way, shadowing can be put in with fine lines. Without these shadings, pen and ink drawings may look flat and two-dimensional.

An interesting project to try with pen and ink is to go outside and sketch trees from observation. Look closely at shapes, directions of branches, the sharp points or rounded shapes of leaves, the pattern of the bark on the tree trunks, the roots, if they show. Pen and ink is an excellent medium to use for scratchy textures of bark, the jagged, smooth lines of branches, or the sharp detail of clumps of leaves and twisted roots.

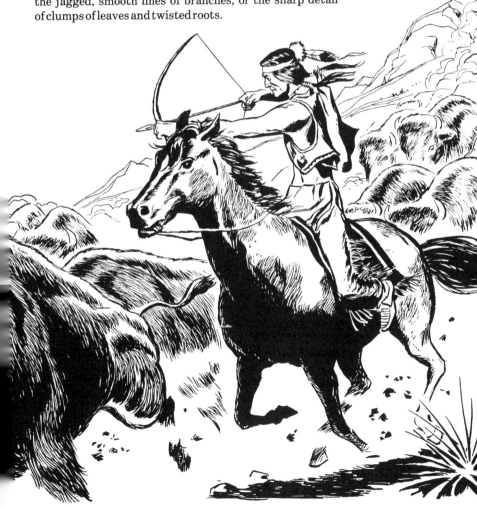

Watercolors

Undoubtedly you have used watercolors ever since you were a small boy, so you know something about working with them.

If you have not, here are a few tips:

• Don't use very thin paper; it will wrinkle as it dries. Glue the paper down to avoid wrinkles.

• Sketch your painting first *lightly* with a pencil.

• Work from light to dark areas. If you make an area too dark, it will be hard to lighten it.

• Remember that tints become lighter as they dry; allow for this by making your painting a little darker than you want.

Try many ways to create effects with watercolors. For example, dampen the page first with a sponge or a wet piece of cloth, and then let the colors flow. You have to guide them, and also blot the paper in places where it gets too

wet, but many exciting color and shape effects can result. Also, try dabbing paint on with a small wad of paper towel; try dropping small drops of paint onto a wet area of paper. Some of these unusual effects are exciting ways to express skies and the sea.

Try painting an imaginary seascape or a storm in a forest using these various effects to make the sea and the waves toss or the sky and clouds roll in many colors.

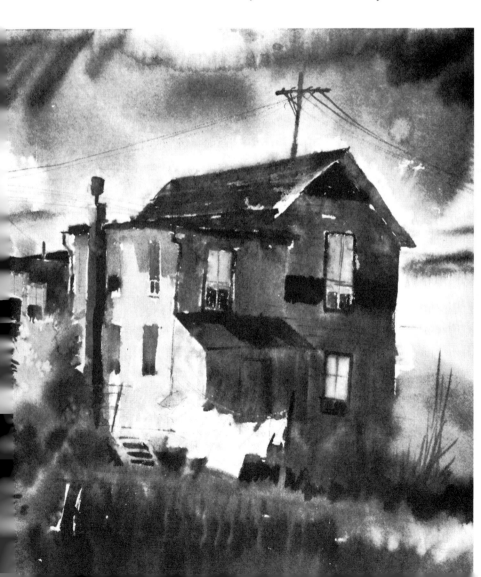

Pencil Drawing

A professional artist might use three or even more different pencils on a single sketch. The pencil he uses depends on what he wants to achieve and the kind of paper he uses. He might have seven or eight pencils, plus a soft charcoal pencil for a smooth drawing with subtle tones. You can use charcoal for your pencil drawing if you want.

If you use pencil, three kinds ought to be enough—one medium hard, one medium soft, and one soft. Manufacturers do not have a standard system for numbering their pencils, but if you have Nos. H, 2B, and 5B, you will have a good range, no matter what the brand of pencil.

Try not only different kinds of lead pencils, but different ways to hold and use the pencils—shading with the side of a pencil, making sharp lines with the point, pressing hard for heavy tones, making broad and narrow kinds of lines, dotting and flecking for texture effects.

An interesting project with pencils is to collect nature forms, such as pine cones, sea shells, twigs and sticks, pebbles, and thistles, and then use pencils to make sketches. Try to create many kinds of textures and lines and tones, making your pencils express the softness, hardness, and form of the various nature objects.

Artists who do a lot of pencil drawing often use special paper. Any paper will do for your purposes, but for best results, use one that is fairly smooth but not hard. Put five or six sheets under the one you are working on; the paper will "give" a little under the pencil and make a smoother job.

Don't try to make a real big drawing. You can lay on paint in broad strips; but with a pencil, if you have a lot of area to cover, you will be pretty tired when you are through.

A kneaded eraser is better than the kind that you have on your school pencils. It will pick up pencil marks and dirt without smearing.

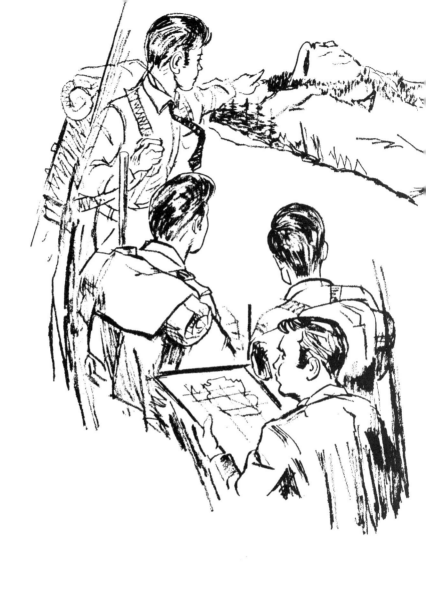

Pastels

Pastels are special crayons that give soft, delicate colors like watercolors. Usually, they are in the form of sticks, although there are pastel pencils, too.

Pastel tends to smudge and smear easily, so a completed picture must be covered with a special fixative spray to protect it. Two coats are used for permanence.

To start a pastel picture, first make a pencil drawing of your subject. Then put that on a pad of five or six sheets of paper and put over it the sheet of paper on which you will do your pastel. Now with your pastel colors, "paint" in your picture; you must be able to see your drawing through the paper on which you are doing the pastel.

Pastel colors darken a little when they are "fixed," so put on the colors a little lighter than you want them to be. If you want your colors to blend into one another—on shadowed areas, for example—rub them lightly with a fingertip. There are gray pastels, with colors ranging from white to black, for shadowing and dark areas.

Before you "fix" your picture, clean the white areas with a kneaded eraser. Then blow off the dirt and loose color and spray with the fixative. Let it dry for a few seconds and spray it again.

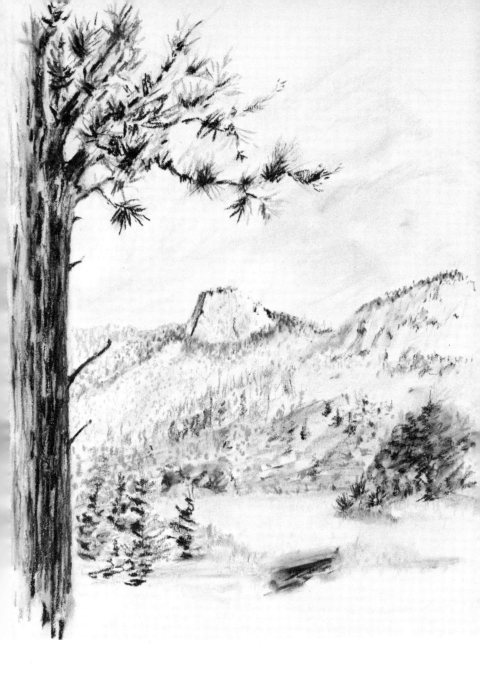

Oil Painting

Oils are probably the most difficult to use of the seven media in this requirement. This is not because the technique of painting is hard, but because more equipment is needed and more knowledge of how to handle it is essential.

You can paint in oils on artist's canvas (there are several kinds), canvas paper or wood, or composition board. If you're trying oils for the first time, get small tubes of the following colors:

Alizarin crimson; cadmium red, light; cadmium yellow, light; yellow ochre, burnt sienna, and raw umber (browns); viridian green, ultramarine blue, and titanium white. Many other colors are available but these will be enough for a start. In addition, you will need gum turpentine and linseed oil, a couple of cups for oils and paints, a palette, and rags.

Brushes are, of course, very important. Start with a short, flat bristle brush and a round sable brush. Artists regularly use several others, but these will do for a start.

The art of preparing your canvas properly and mixing your colors can only be learned by practice. But you may save yourself time and trouble by getting some tips from one of the books on painting listed at the end of this pamphlet before plunging in.

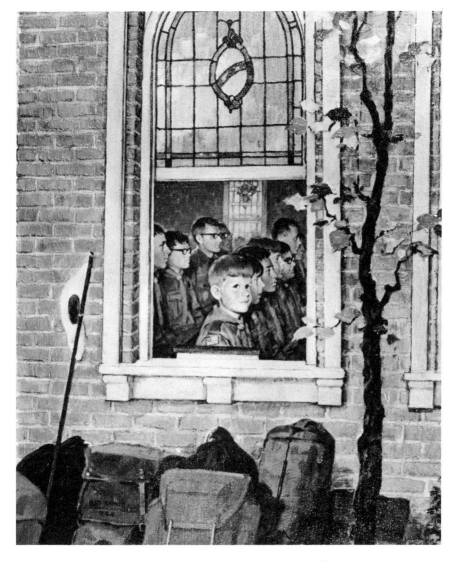

Tempera

Tempera is poster paint, the kind you have probably used many times in school. It can be used to paint on any surface except canvas.

Like watercolors, tempera paints are soluble in water, but the paint is not so transparent as watercolor. Tempera paint gives brighter, stronger colors and does not dry quite as fast.

To use tempera, you need brushes of various sizes, the paints, which may be liquid, paste, or powder, a couple of jars to hold water, and a "palette." Some old saucers or an aluminum TV dinner plate will serve nicely as a palette for mixing colors.

Start your painting by sketching it lightly in pencil. When you begin painting, lay on your large areas of color first. Save the details and smaller areas for last.

As with other media, lots of practice is necessary before you will be able to achieve all the tones you want. If you have not used tempera very much before, you will want to experiment with it a few times before you begin the painting for this requirement.

Use flat bristle brushes for large washes of color and round or flat sable brushes for outlining and filling in the important small details.

Tempera paint can be used thin, with more water in it, or thick and heavy with very little water. To get rich effects, use it both thin and thick, with both large and medium brushes. See how many kinds of colors you can create so your painting will have rich unusual tones. For example, if you are making a sky in your painting, do more than just mix a blue color—try many brushstrokes of many kinds of blue, some green, some gray,purples, browns, even dashes of red. Your sky will seem much more dramatic.

Shortcuts

Art is a personal matter, just between you and your pencil, pen, or brush. Nobody can tell you exactly how they should best be used to do your drawing or painting. But experienced artists have found a few shortcuts that may save you a lot of time in learning. On the next few pages are a few tips for young artists.

Acrylics

A relatively new material gaining rapid popularity, acrylics dry hard in brilliant colors. This synthetic material also is unaffected by extremes in the weather.

Since acrylics go on easily, they can be used on almost any surface—cardboard, paper, fabric, and wood. Different colors can be painted over one another in a short time because acrylics dry almost immediately forming a waterproof surface.

Try to create different textures when working with acrylics, from thick and rough to almost transparent. Acrylics can be thinned, and heavy coatings of transparent color can be made to resemble stained glass.

But remember, since acrylics dry quickly they do not tolerate mistakes.

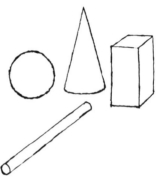

GEOMETRICAL FIGURES. Almost any sketch can be reduced to geometrical figures like these. So try starting a sketch with balls, cones, cubes, and cylinders, then fill them out the way you want.

THUMBNAIL SKETCHES. Most artists like to make very small sketches of their subject until they find one that seems good. These small sketches are useful in acquainting you with your subject from several angles.

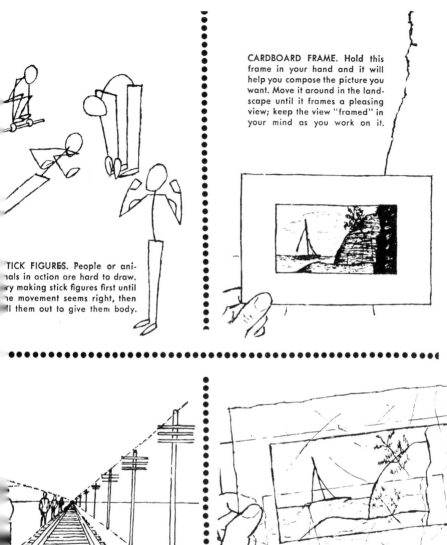

CARDBOARD FRAME. Hold this frame in your hand and it will help you compose the picture you want. Move it around in the landscape until it frames a pleasing view; keep the view "framed" in your mind as you work on it.

TICK FIGURES. People or animals in action are hard to draw. Try making stick figures first until the movement seems right, then fill them out to give them body.

PERSPECTIVE. To give your work depth, make the objects in the foreground bigger than those in the background. A road recedes to a point on the horizon and buildings appear smaller at a distance. Of course, you may sometimes distort perspective on purpose to get a special effect.

TRACING PAPER. This material is useful in transferring a sketch onto the surface you intend to draw or paint on. Ordinary carbon paper can be used if you are careful not to smear it, or you can cover the back of the sketch paper with charcoal dust and make the transfer in this way.

7 VOCATIONS

IN ART

For tens of thousands of Americans art is a way of life and a way of making a living. For the fine artist—the painter or the sculptor busy in his studio—it is his life. Often he begins a work with no idea of who might buy it. Perhaps no one will for years. But if you have the intense desire to create, nothing will stop you from doing it.

To the commercial artist, art is also a way of making a living, and a way of life, but he expects to be paid for each work.

Thousands of commercial artists work in advertising agencies, art services, publishing businesses, department stores, large printing plants, engraving and lithographic businesses, greeting card manufacturing plants, textile plants, and sign and poster studios.

They are mainly specialists in one phase of artwork — illustrators, letterers, layout men, typographers, airbrush artists, sketchers, window-display designers, fashion designers, book-jacket designers, textile designers. In most of these fields, there are also free-lance artists who sell their services to businesses.

Thousands of artists are employed in industrial designing. And there are smaller fields like stage and costume design, cartooning, and the special craft of animated cartoons for TV and movies.

Successful artists—both "fine" and commercial—are trained. Most of them today are graduates of art schools. Schools cannot produce artists; only ability and experience can do that. But a school can help a beginner learn his craft.

If you think you might enjoy a career in art, your high school guidance counselor can put you in touch with a good art school. If there is an art studio in your community, try to get summer work there. Even in the lowest job, you can learn something about art.

8

REPRODUCING ART

The drawings, paintings, and text in this booklet were reproduced by a printing process know as offset. On the opposite page an offset press is printing a merit badge pamphlet.

This type of reproduction is used for newspapers, magazines, and books as well as booklets like this.

Most other types of reproduction are also printing processes. The only exception is silk screen, which is reproduction by stencil.

There are three ways to print art:

1. From a raised surface—Relief photoengravings on a letterpress, block prints, woodcuts, drypoint.

2. From a sunken surface—Photogravure, which is similar to relief photoengraving except that the design is sunk and the background is high, and etching.

3. From a flat surface — Lithography, offset lithography.

Each type of reproduction has advantages and disadvantages. On the following pages we will examine each type in a little detail.

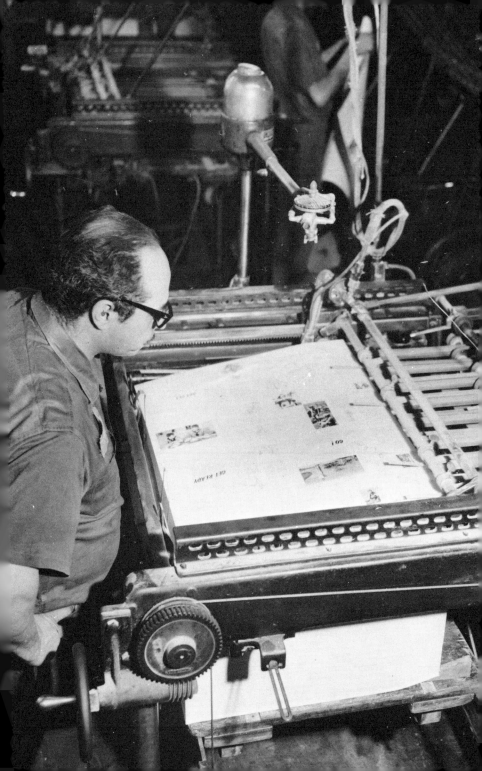

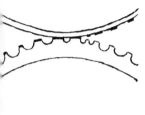

Photoengraving

This process combines the arts of photography and etching metal with acid. First a photographic negative is made of the art to be reproduced. The photoengraver places this negative against a sheet of metal that has been covered with a chemical solution that hardens quickly when it is exposed to light. When he turns on the light, it can reach the metal plate only through the transparent parts of the negative so that the chemical solution hardens only in those places. Next he washes away the rest of the solution and brushes a powdered resin over the plate; it sticks only where the solution has hardened. Then the plate is put in an acid bath. The acid eats away the metal that is not covered by the resin. This leaves the design raised on the plate for printing. The same principle is used for photogravure, except that the design is etched by the acid, leaving the background raised.

Lithography

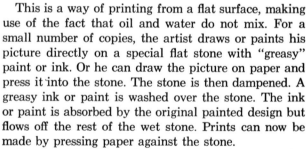

This is a way of printing from a flat surface, making use of the fact that oil and water do not mix. For a small number of copies, the artist draws or paints his picture directly on a special flat stone with "greasy" paint or ink. Or he can draw the picture on paper and press it into the stone. The stone is then dampened. A greasy ink or paint is washed over the stone. The ink or paint is absorbed by the original painted design but flows off the rest of the wet stone. Prints can now be made by pressing paper against the stone.

Commercial lithography is based on the same principle, but the techniques are much more involved. Metal plates and photographic processes are used in place of stone and handcraft. In offset lithography, the printing is done by a rubber-covered cylinder instead of the metal plate.

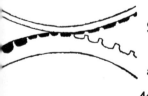

Silk Screen

This process is used in reproducing fine art pictures and in commercial printing. A piece of silk is stretched

across a wooden frame. A stencil is then put on the silk. It may be painted on the silk, it may be a cutout, or it may look like a photographic negative. Paint is forced through the open places in the stencil onto the paper to be printed. A new stencil has to be used for each color in the painting, and the artist has to wait until each color has dried before he can do the next one.

Etching

Etching means engraving on metal or glass with acid. First the artist covers the plate with a substance that won't be affected by acid. On this etching ground, he draws or traces his design with a sharp tool, exposing bare metal or glass. The plate is then placed in an acid bath, and the acid eats away the bare places.

To make prints from the plate, the artist covers it with ink and then wipes it off. Little rivers of ink are left in his design. When paper is pressed against the plate, it lifts the ink. His design then is in tiny ridges of ink on the paper.

Drypoint

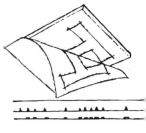

This is a method of engraving with a very fine needle. The artist scratches his design on a metal plate. The needle throws up a burr along the line as he scratches it. The printing is done from this burr. It holds the ink, and, when paper is pressed against the plate, the burr transfers the ink to the paper. Drypoint engravings have a rich, velvety black texture.

Block Printing and Woodcut

These methods of reproduction are treated together, because they both involve carving to make a relief design for printing—that is, a block with the background cut away. The material for the block may be wood, linoleum, metal, plastic, or even cardboard. Using knives, chisels, and gouges, the artist cuts away the block's surface except the part to be printed. To print from the block, the artist puts ink or paint on these surfaces and presses paper against the block.

Books About Art

Recommended by the American Library Association's Advisory Committee to Scouting

Belves, Pierre, and Mathey, Francois. *How Artists Work: An Introduction to Techniques of Art.* Lion Press, 1967. Examples of the use of a wide variety of materials and techniques from all over the world throughout history.

Bockus, H. William. *Advertising Graphics.* 3d ed. Macmillan, 1979.
Workbook and reference for the advertising artist; includes tools, layout, and methods of reproduction.

Cumming, Robert. *Just Look . . . A Book About Paintings.* Scribner, 1980.
How a variety of famous artists achieved their effects by their use of perspective, modeling, anatomy, light, color, and mood.

Cummings, Richard. *Make Your Own Comics for Fun and Profit.* Walck, 1976.
Planning the story, preparing and finishing the art work, and how to get published.

Downer, Marion. *Discovering Design.* Lothrop, 1947.
Drawings and photographs demonstrate that design is all around us, to be found in line, balance, rhythm, symmetry, repetition, etc.

Downer, Marion. *The Story of Design.* Lothrop, 1963.
The historical development of design; what influenced the artist to create particular designs.

Gollwitzer, Gerhard. *Express Yourself in Drawing.* Cornerstone, 1976.
For the beginner. Suggestions for paper and tools and how to use them with exercises in composition and handling of forms. Monochrome only – pencil, ink, chalk, and charcoal.

Gombrich, E. H. *The Story of Art.* 13th ed. Phaidon, 1980.
A history of art, with hundreds of photographs and reproductions.

Gordon, Louise. *How to Draw the Human Figure: An Anatomical Approach.* Viking, 1979.
How to use a knowledge of anatomy in drawing.

Guptill, Arthur L. *Drawing With Pen and Ink*. Rev. ed. Van Nostrand, 1979.
Detailed, step-by-step instructions for the beginner, using ink with pen or brush. Many illustrations.

Guptill, Arthur L. *Oil Painting Step by Step*. 3d ed. Watson-Guptill, 1965.
Simple, clear instructions on choice and care of materials and handling of subjects of increasing difficulty.

Hoff, Syd. *The Art of Cartooning*. Stavron, 1973.
From ideas and drawing techniques to marketing cartoons and comic strips, with plenty of samples to show how it is done.

Horton, Louise. *Art Careers*. Watts, 1975.
Discusses interior, graphic, and industrial design, illustration, fine art, etc. List of colleges offering training.

Janson, H. W. *History of Art: A Survey of Major Visual Arts From the Dawn of History to the Present Day*. Abrams, 1977.

Nicolaides, Kimon. *The Natural Way to Draw*. Houghton, 1941.
A classic on the subject; very detailed. Includes reproductions from the masters.

Ross, Al. *Cartooning Fundamentals*. Stavron, 1977.
Sketching styles and techniques; cartoons as art.

Ruskin, Ariane. *History of Art*. Watts, 1974.
Beautifully reproduced highlights of western art from ancient Egypt to the present, each chosen to portray the artist's time and place.

Smith, Dian G. *Careers in the Visual Arts: Talking With Professionals*. Messner, 1980.
Descriptions of their jobs by artists such as art therapists and landscape architects, and by people in related work such as curators, conservators, dealers, and editors.

Taubes, Frederic. *Oil Painting for the Beginner*. 3d ed. Watson-Guptill, 1965.
Full description of basic materials and tools; step-by-step instructions for portrait, still life, and landscape painting.

Weiss, Harvey. *Paint, Brush and Palette*. Addison-Wesley, 1966.
The techniques of using light, color, shape, and form; characteristics of different kinds of paints and how to use them.

CREDITS

Joseph Csatari
 pages 29 and 35

John Dunigan
 page 43

Federal Aviation Agency (S.S.T. photo)
 page 23

Joseph Forte
 page 15

Stanley Harris
 cover and page 40

Norman Rockwell
 page 9

Wide World Photos
 page 25